CHRISTOPHER HART'S
DRAW MANGA NOW!

Magical Characters

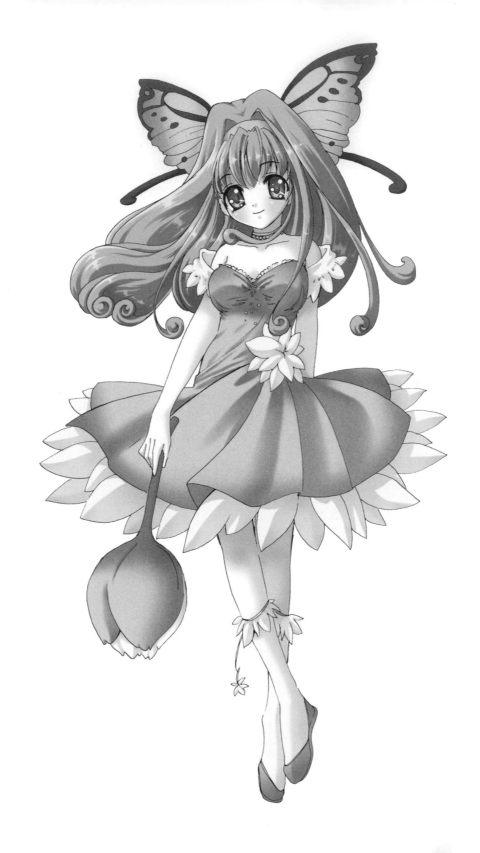

CHRISTOPHER HART'S DRAW MANGA NOW!

Magical Characters

Christopher Hart

Watson-Guptill Publications
New York

Published in the United States by Watson-Guptill Publications, an imprint of the Crown Publishing Group, a division of Random House, Inc., New York.

www.crownpublishing.com
www.watsonguptill.com

WATSON-GUPTILL is a registered trademark and the WG and Horse designs are trademarks of Random House, Inc.

This work is based on the following titles by Christopher Hart published by Watson-Guptill Publications, an imprint of the Crown Publishing Group, a division of Random House, Inc.: *Manga Mania Magical Girls and Friends*, copyright © 2006 by Christopher Hart; *Manga Mania Occult and Horror*, copyright © 2007 by Star Fire LLC; *Manga for the Beginner Shoujo*, copyright © 2010 by Cartoon Craft LLC; and *Manga for the Beginner Kawaii*, copyright © 2012 by Cartoon Craft LLC.

Library of Congress Cataloging-in-Publication Data

Hart, Christopher, 1957-
 Magical characters : Christopher Hart's draw manga now! / Christopher Hart. — First Edition.
 p. cm
1. Comic books, strips, etc.—Japan—Technique. 2. Drawing—Technique. 3. Fantasy in art. I. Title.
 NC1764.5.J3H3692845 2013
 741.5'1—dc23
 2013002123
ISBN 978-0-385-34548-4
eISBN 978-0-385-34535-4

Cover and book design by Ken Crossland
Printed in the United States of America

10 9 8 7 6 5 4 3 2 1
First Edition

Contents

Introduction

Magical characters are super-popular among manga fans from New York to Tokyo. They are the stars of graphic novels, anime TV shows, and feature films. Magical girls are, typically, schoolgirls who are suddenly called upon to save another world that's in danger. To do this, they are given special powers that transform them into glamorous "magical" versions of themselves. Because magical characters usually come with a lot of ornate accoutrements, such as clothing, hair, mascots, and accessories, building a foundation for them is important; without understanding all these elements, the magical aspects of your characters will be less convincing. Without it, the magical aspects won't look convincing. Let's put a little magic in your arsenal of manga drawing techniques, and learn how to draw magical characters like the pros.

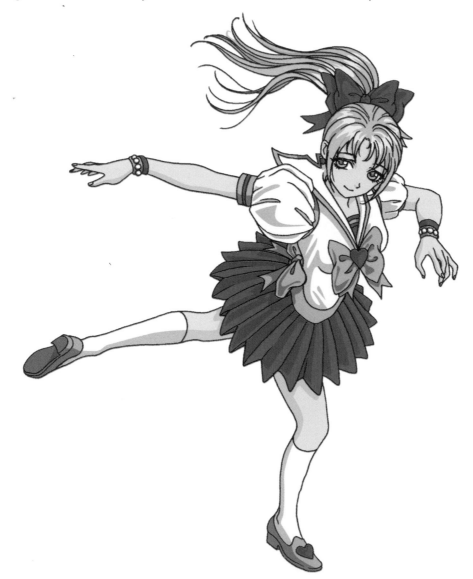

To the Reader

This book may look small, but it's jam-packed with information, artwork, and instruction to help you learn how to draw the magical characters of manga like a master!

We'll start off by going over some basic manga drawing concepts. Pay close attention; the material we cover here is very important and provides the foundation on which you build your characters. You might want to practice drawing some of the things in this section before moving on to the next one.

Then, it'll be time to pick up your pencil and get drawing actual magical manga characters! You'll follow the step-by-step illustrations on a separate piece of paper, drawing the characters in this section using everything you've learned so far.

Finally, I'll put you to the test! The last section includes images that are missing some key features. It'll be your job to finish these drawings, giving the characters the elements they need.

This book is all about learning, practicing, and, most important, having fun. Don't be afraid to make mistakes, because you never know when something that you think is a mistake works as a springboard to a great idea. Also, the examples are meant to be guides; feel free to elaborate and embellish the illustrated examples as you wish. Before you know it, you'll be a manga artist in your own right!

Let's begin!

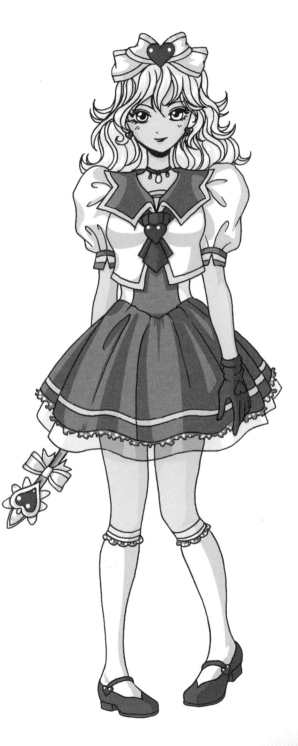

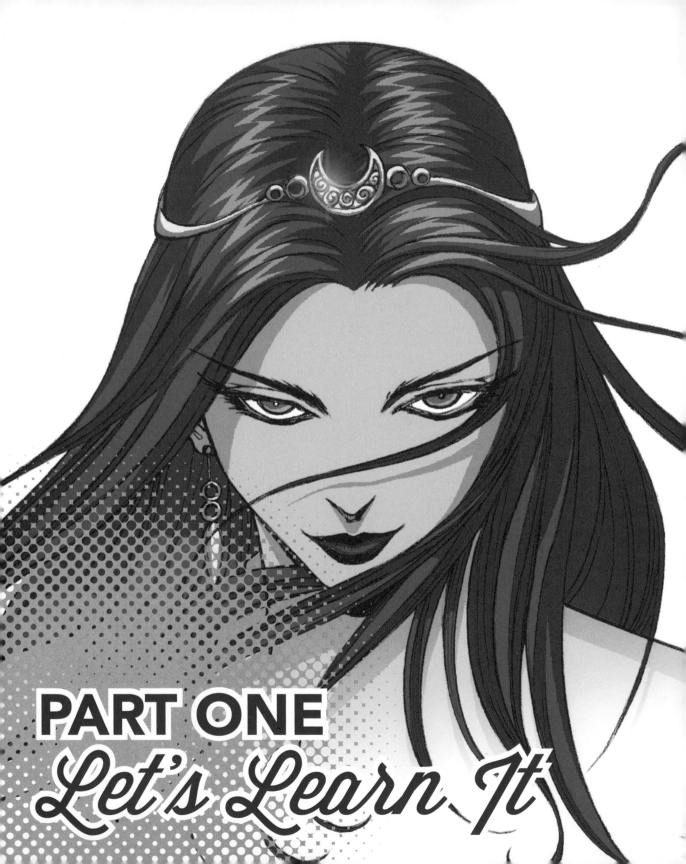

PART ONE
Let's Learn It

Basic Head Construction

You'll get a chance to look at bodies in the second section of the book, but let's just look at the basic head construction quickly to get started.

The face of younger females, such as magical girls and other magical characters, retains the soft, round look of a preteen but with the feminine features of an older teenager, notably the heavy eyeliner and eyelashes. She should have a friendly, youthful face, which you can give her by drawing large eyes. Leave a good amount of space between the eyelids and the eyeball. That makes her look sincere and honest. Keep her face on the round side.

Female Front View

The front view focuses attention on the eyes like a laser beam. This is the most prominent feature of the manga face.

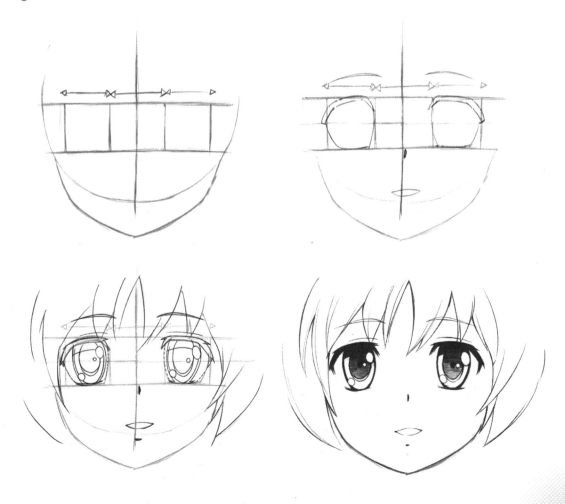

Female Profile

Look how easy this is! As with the front view, you start with an egg shape. But you have to delicately carve out small areas and curves in the front of the face while leaving the general outline in place. It's especially important to leave a soft underside to the chin. This keeps the character youthful and feminine. It makes her a "good" character, as opposed to an "evil" one, who has hard and angular features.

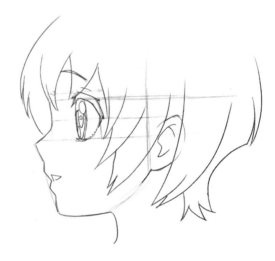

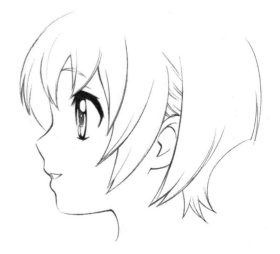

Male Front View

Like girls, many boy magical characters are also about 14 to 16 years of age. But they can sometimes appear even a bit older if their features are longer and more elegant (a type of character known as a bishounen, or bishie for short, which in Japanese stands for *pretty boy,* and is a standard character type pervasive in many styles of manga).

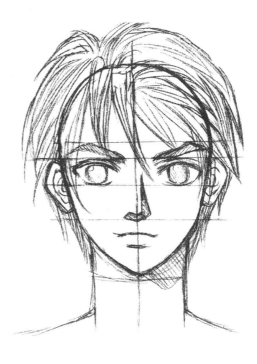

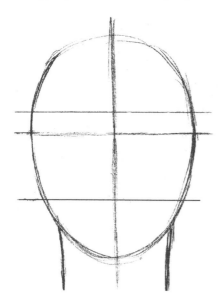

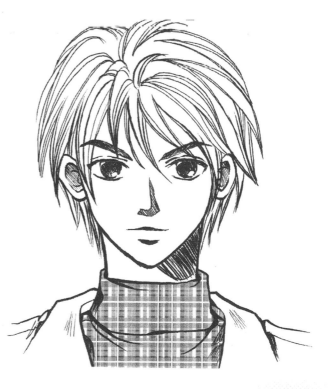

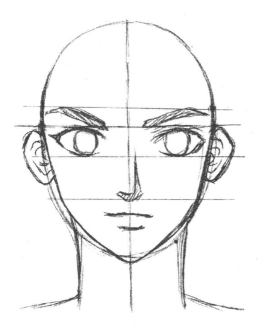

Expressions for Magical & Fantasy Characters

Here are a few classic magical girl expressions, with some other characters thrown in—like elves and vampire hunters. Magical and fantasy characters are often portrayed as heroic, which means that their expressions have to reflect a certain inner strength. At the same time, the good guys and gals of this style are charming, sweet, and helpful. Here are some examples of expressions that show rugged determination, as well as hopeful, peaceful qualities.

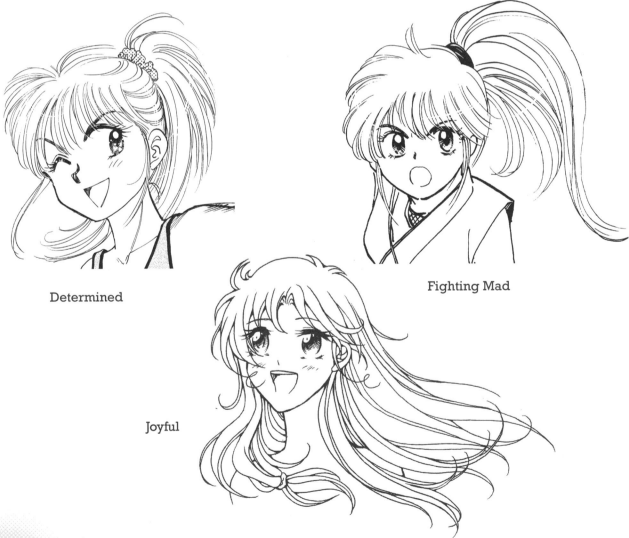

Determined

Fighting Mad

Joyful

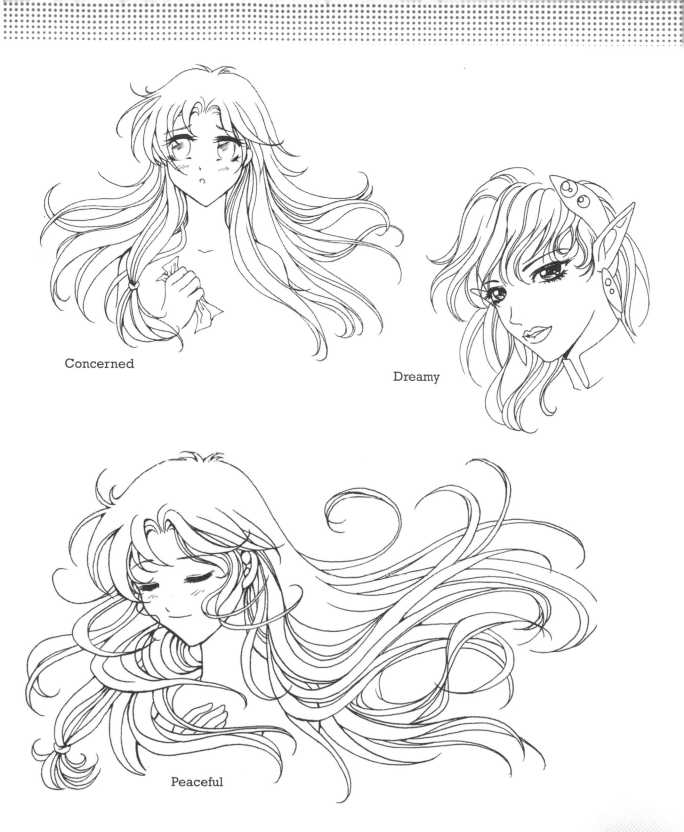

Concerned

Dreamy

Peaceful

Magical & Dramatic Hair

One of the things that makes magical and fantasy characters identifiable is that they have mysterious forces working on them that ordinary people do not see or experience. They also have a lot more hair than you or I—or regular manga characters—do.

Adding long, dramatic hair that curiously blows in the breeze, even if there is no breeze, adds to the feeling that we are in the presence of a magical or supernatural being. Take a look at these comparisons.

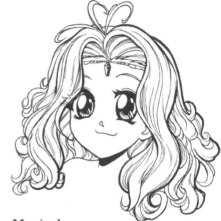

Ordinary
Her hair is wavy, but not as wavy as it could be.

Magical
Now she has super-wavy, curly locks, which are further embellished with a headband. Flyaway hair almost makes her look as if she's wearing a crown.

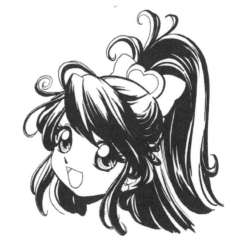

Ordinary
Her stick-straight hair is cute, but not dramatic enough for a magical girl.

Magical
Pump up the volume! She has a huge ponytail, adorned with a giant bow, and a few wild curls.

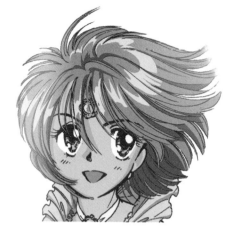

Not Dramatic
The hair is too short and choppy here. It doesn't flow together in a fluid manner.

Dramatic
Her hair becomes animated, blowing freely in the air and swooping to one side. The light has a special effect on her hair, which seems to glow. Note the gem that also adorns her forehead. Not only does it add visual interest, but it also suggests her magical powers.

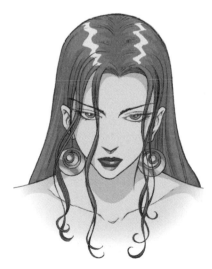
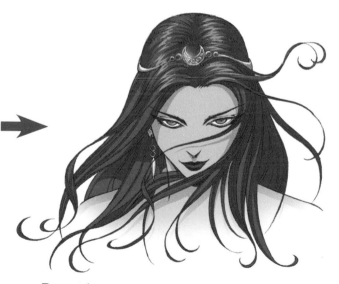

Not Dramatic
There's no breeze to affect this hairstyle. The long strands are a good touch, but nothing interesting is happening with them.

Dramatic
The hair is fantasy-oriented, blowing randomly not so much from a breeze but as if levitated by a spirit. And it is topped off with a bejeweled headband. (Note the denser eye makeup, fuller and darker lipstick, and thicker eyebrows, which, not coincidentally, are drawn at a sharper angle.)

Magical Girl Transformation

Sometimes, a magical girl can be sent from another world to come to Earth and fit in as an Earth girl, which is difficult given the superior powers that she must keep under control if she is to conceal her secret identity.

To see how a magical girl gets from here to there in a logical progression, let's go step by step from the ordinary to the extraordinary.

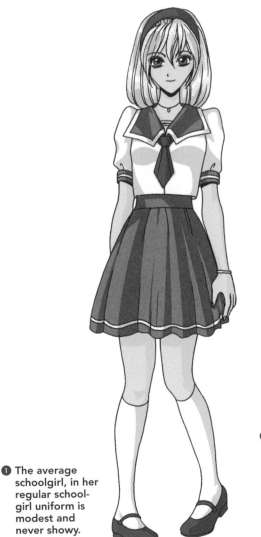

❶ The average schoolgirl, in her regular school-girl uniform is modest and never showy.

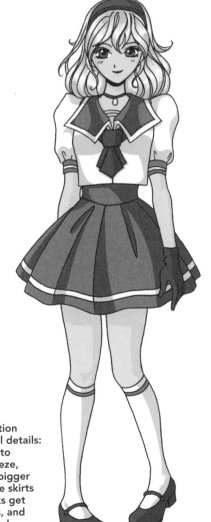

❷ The transformation starts with small details: the hair begins to blow in the breeze, the collar gets bigger and showier, the skirts widen, the socks get embellishments, and gloves are added.

What Makes a Magical Girl?

The magical girl is a type of character found in shoujo (Japanese comics aimed at young girls); however, magical girls also appear across many genres and character types. You definitely need to have these in your repertoire. The magical girl starts out as a typical schoolgirl. Her transformation—via a glamorous costume, and amplified by special powers—gives her a new identity. She would be the last person in the world to believe that something amazing was about to happen to her.

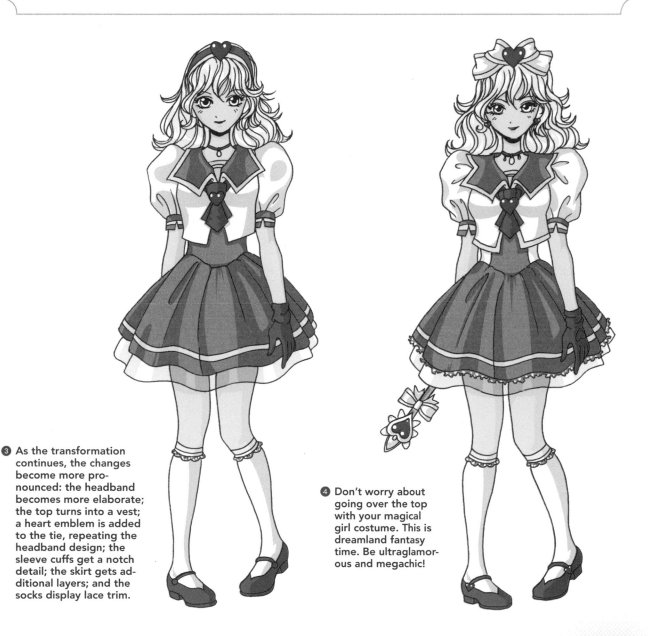

❸ As the transformation continues, the changes become more pronounced: the headband becomes more elaborate; the top turns into a vest; a heart emblem is added to the tie, repeating the headband design; the sleeve cuffs get a notch detail; the skirt gets additional layers; and the socks display lace trim.

❹ Don't worry about going over the top with your magical girl costume. This is dreamland fantasy time. Be ultraglamorous and megachic!

Magical Girl Character Types

There is a wide range of magical character types, from schoolgirls to princesses to elves to anthros (mysterious creatures that are humans with animal traits). Here are just a few. The figures here provide some of the many possibilities.

Princess Fighter

Bunny Anthro

Schoolgirl

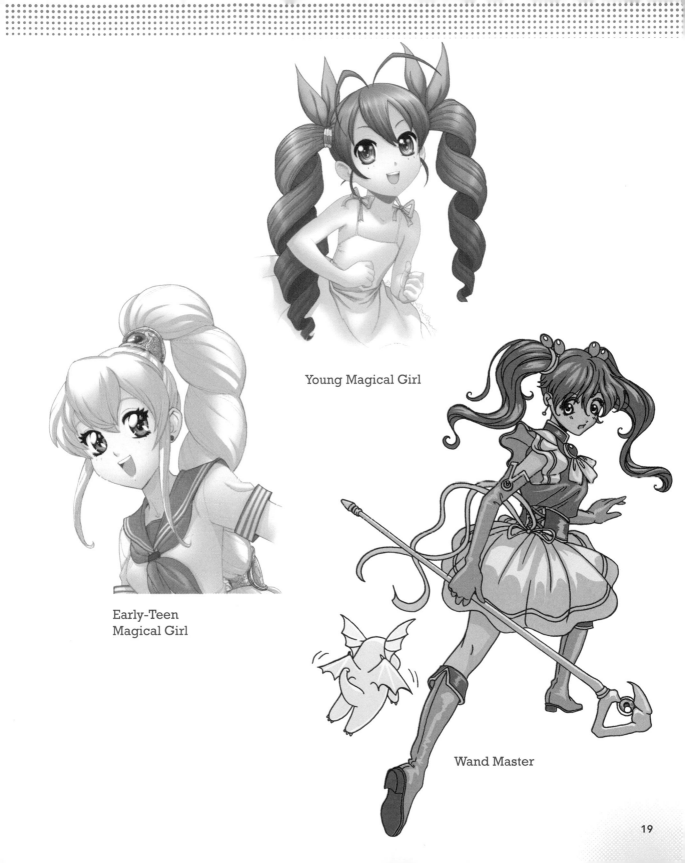

Young Magical Girl

Early-Teen
Magical Girl

Wand Master

Villains

When characters are less sweet—and more on the "evil" or otherworldly side—their hair, expression, facial features, and clothing all change. Villains often appear a little older, too. Take a look at these menacing characters, and pay attention to the details that make them look so venomous.

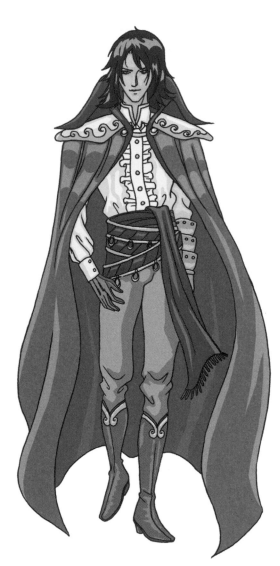

Occult Prince

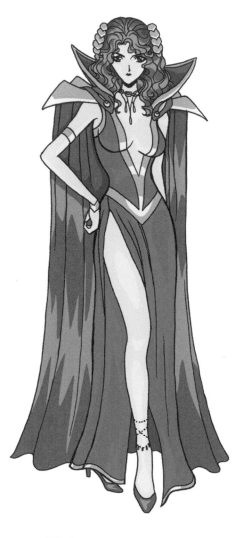

Evil Princess

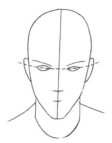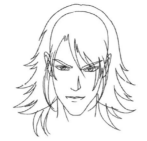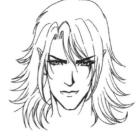

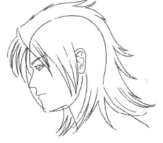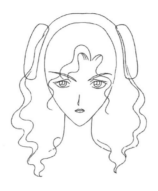

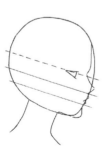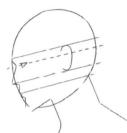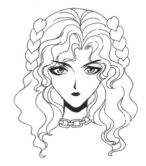

Here we've got some classic villain faces. Note how much the shape of the eye can transform a character's look and demeanor. A trick to making a villain's eyes look especially evil is to not make them tall; instead, they're sleek, narrow, and very horizontal—almost almond-shaped. Draw the eyebrows with a high arch, and angle them sharply down toward the bridge of the nose.

Special Powers

When you're drawing magical girls, you'll want to add appeal to your images with special effects that further convey the fantasy aspects of your characters. Here are a few examples in various styles. Think of their special powers as part of their costumes.

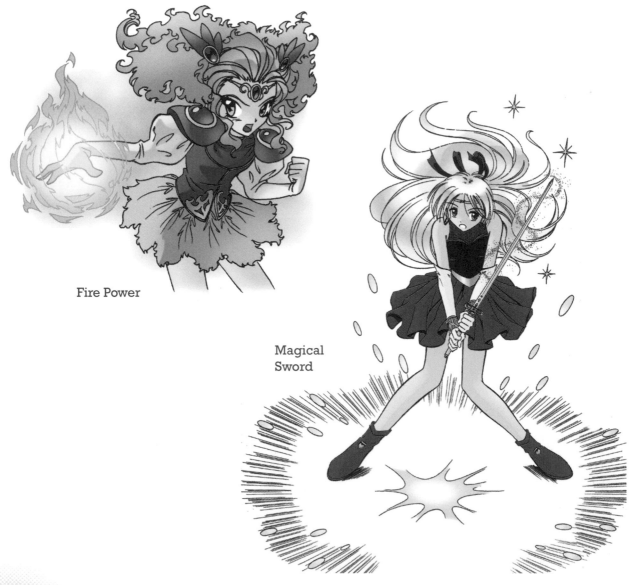

Fire Power

Magical Sword

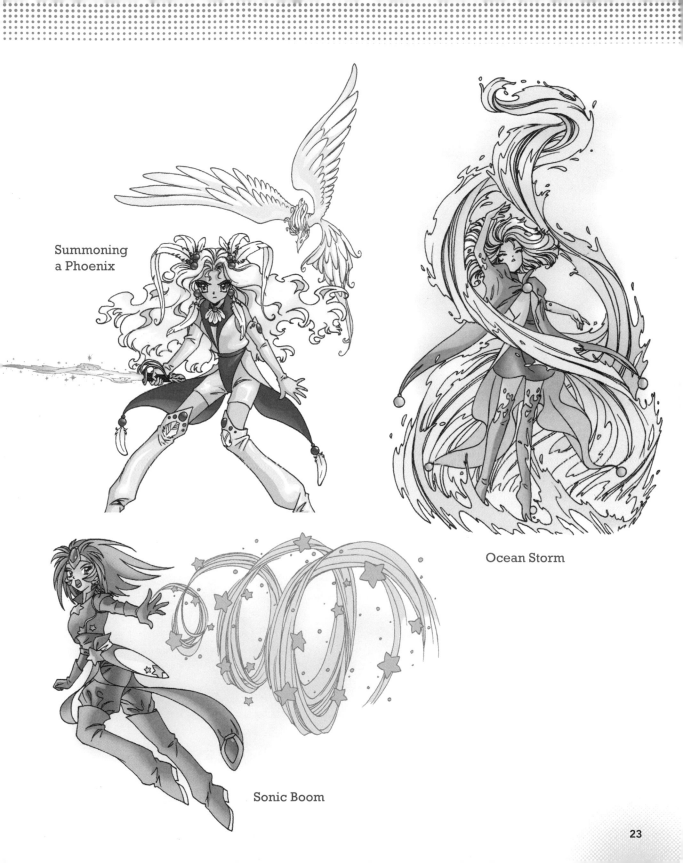

Summoning
a Phoenix

Ocean Storm

Sonic Boom

Magical Accessories

Nothing says "You're finished!" to a bad guy like a magical girl's wand or sword. Magical girls' accessories should be ornate and attractive, but still powerful. They can glow, light up, emit rays of energy, or sparkle. Usually, magical girls' accessories are as functional as they are charming, and provide their owner with some kind of power or special ability. Try incorporating some of the accessories on these pages into your own magical character's design.

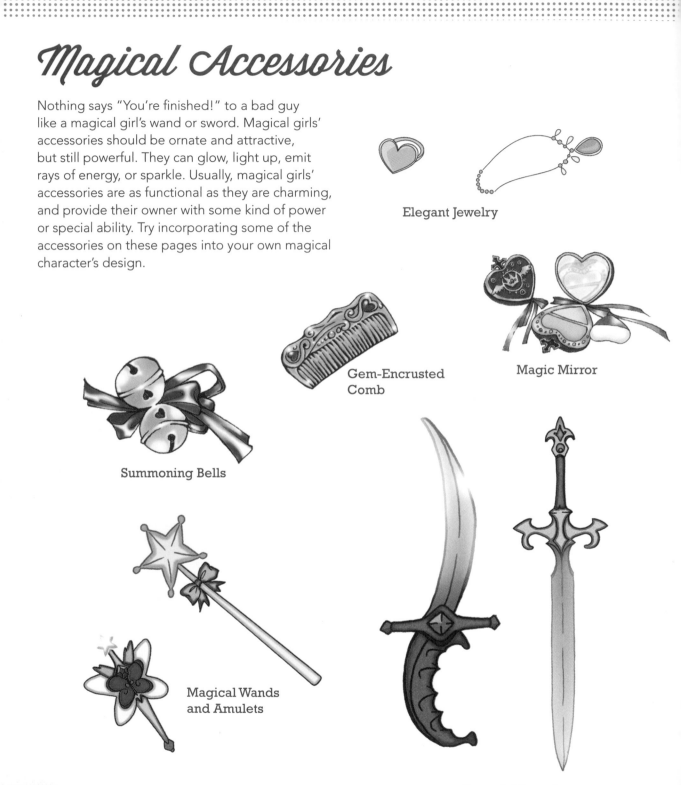

Elegant Jewelry

Gem-Encrusted Comb

Magic Mirror

Summoning Bells

Magical Wands and Amulets

Powerful Swords

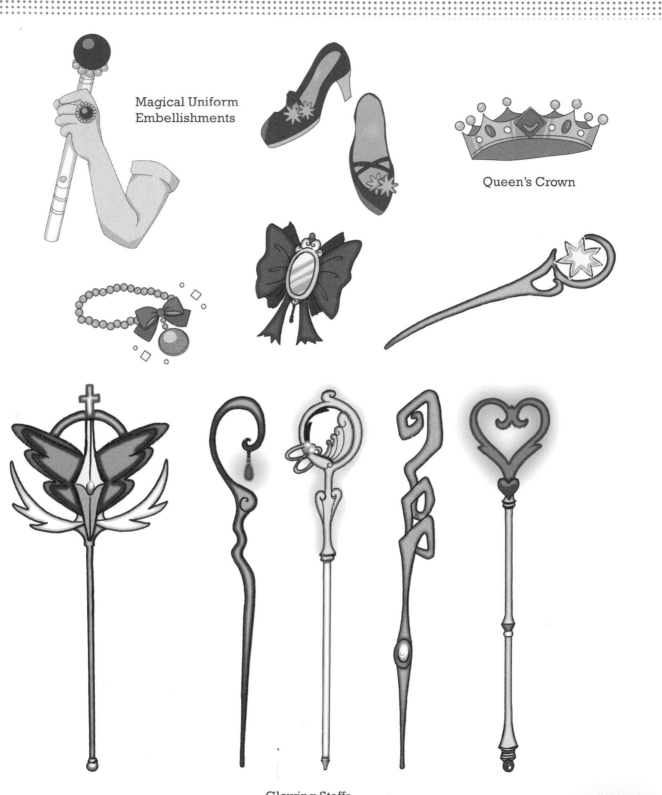

Magical Uniform
Embellishments

Queen's Crown

Glowing Staffs

Magical Mascots

These cuddly little fantasy monsters, rascals really, are pals of the magical girl. They're mascots, buddies, and magical friends who hop along for the ride. Magical girls usually encounter them once they enter the "other world," which could be in another galaxy or another dimension. These chipper little guys are not afraid of danger. In fact, they'll throw themselves into harm's way to protect their companions. There is no finer friend than a tiny manga mascot.

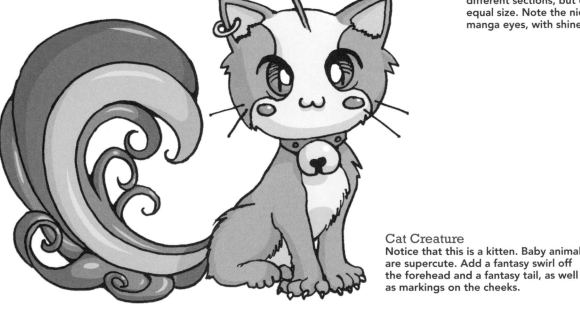

Bunny Critter
The head and body are two different sections, but of equal size. Note the nice manga eyes, with shines.

Cat Creature
Notice that this is a kitten. Baby animals are supercute. Add a fantasy swirl off the forehead and a fantasy tail, as well as markings on the cheeks.

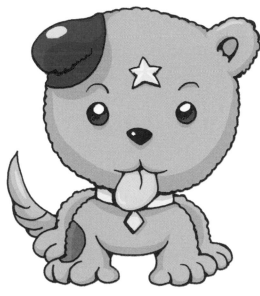

Star-Spangled Puppy

The face is round and young-looking, with manga eyes. And the entire form is ultrasimplified. That star marking on the forehead tells us that this is a fantasy creature.

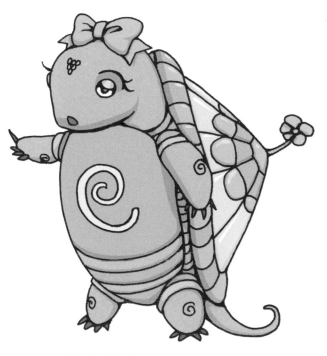

Purdy Turtle

Ever see a turtle walk on two legs? Or have eyelashes? Me neither. Walking on two legs gives the turtle-creature extraordinary speed. Does the mile in just under a week and a half.

Slugger Mouse

Who wants to go three rounds with Squeaky the Tornado? Winner gets a week's supply of cheddar.

PART TWO
Let's Draw It

Magical Flying Girl

This magical girl is posed in such a way that she looks as if she is moving toward you at high speed. To achieve these effects of perspective, her body is sketched along vanishing lines, which converge at a vanishing point. These help artists see how the body gradually gets smaller as it recedes in space. This character wears an elaborate uniform and sports giant, fluffy wings, which propel her forward at top speed. Note how her hair flies back in the wind, also conveying a sense of motion.

Fairy

Fairies work best when shown beside an object—such as a flower—that can reveal their scale. As the flower unfolds, it reveals the fairy inside, and you see just how small this little winged creature really is. Fairy wings are usually translucent and wispy.

In this scene, the fairy has just awakened from her slumber inside of a flowery bedroom. She has a delicious stretch as she rouses herself from sleep.

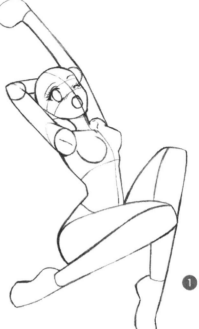

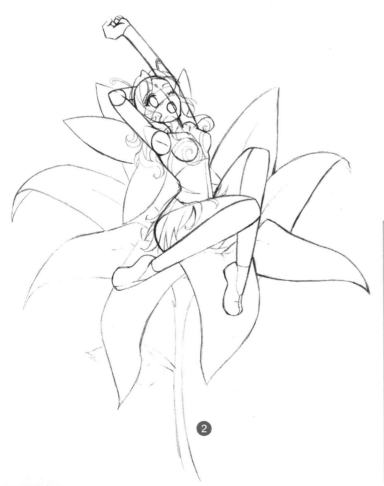

Hint: Sketching

Draw lightly at first. You're putting down construction lines, basic shapes, and guidelines. You'll be erasing many of these lines later on in the process. Therefore, *don't press down too hard on your pencil.* In addition, try not to make very short, choppy, feathery strokes. Comfortable, loose pencil strokes are the best. Tightening up constricts your creativity. It makes you worry too much about "getting it right." This isn't the part where you try to get it right. This is the part where you experiment and see what happens.

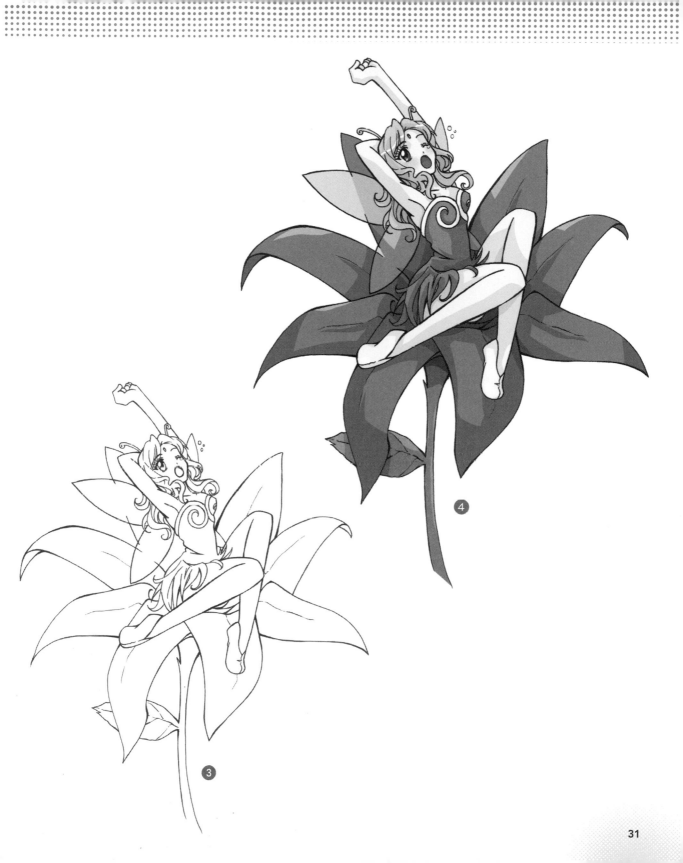

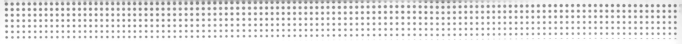

Graceful Angel

Does this type of character look somewhat familiar to you? Take a moment. If it does, that's because robed, winged, ethereal angels appear in many styles of manga and across many genres, from moe to shoujo and shounen and even in the darker styles, like occult and horror. Wings are generally tinged with highlights of blue, gray, or lavender; however, this is fantasy—you can do what you want. What's someone going to say if you color them pink or light green? "Hey, those wings don't look real"? None of it's real!

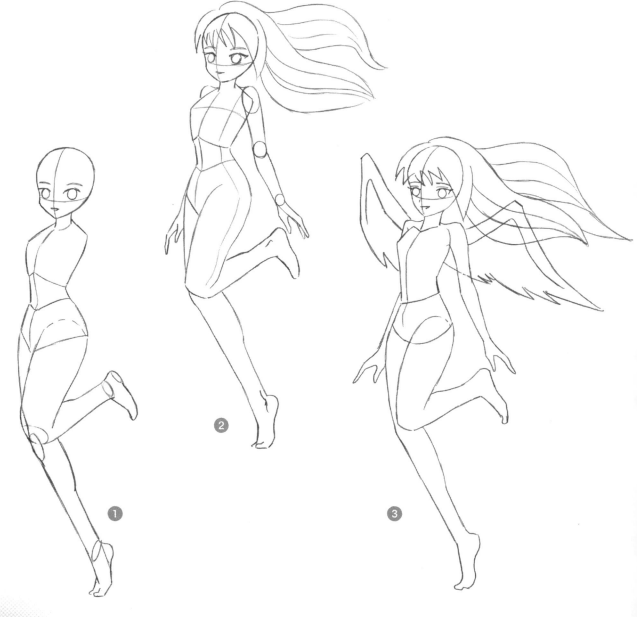

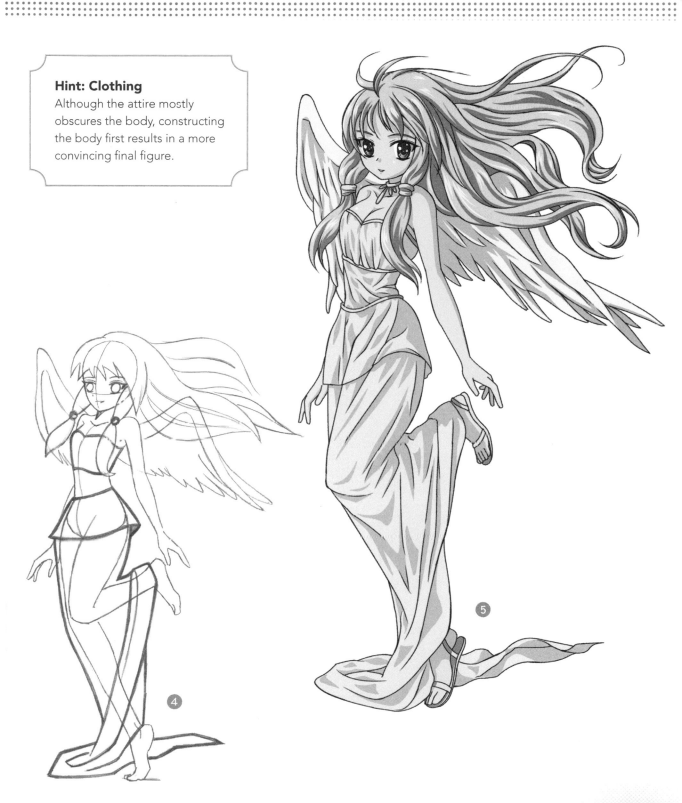

Hint: Clothing
Although the attire mostly obscures the body, constructing the body first results in a more convincing final figure.

Ice Queen

The ice queen is a popular character type who is drawn in many different ways by various artists. She is usually portrayed as cold and evil yet at the same time alluring and beautiful. Her color scheme is usually white and blue—white to signify snow, and blue to signify cold and ice. And that tiara is made of ice crystals, not jewels.

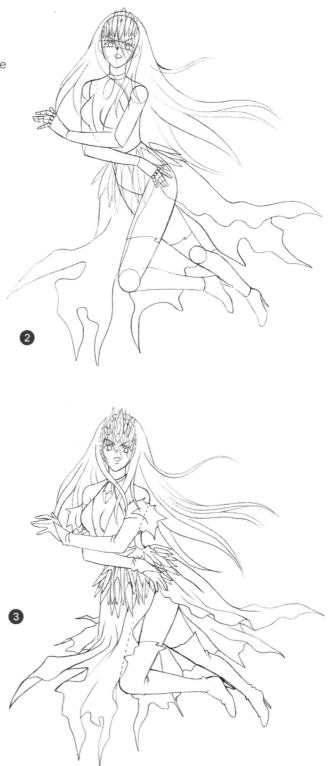

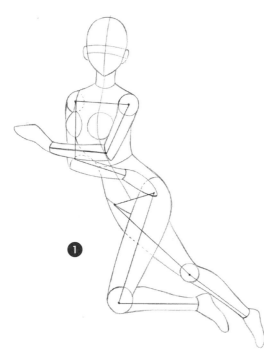

5

4

Wizard

Common to many popular fantasy genres is the wise, old wizard who instructs the young hero or heroine. His bushy eyebrows, long beard, and mustache give him a wise and kindly appearance. Note the witchlike hat; this differs from the western-style wizard, who usually wears a hat that has no brim.

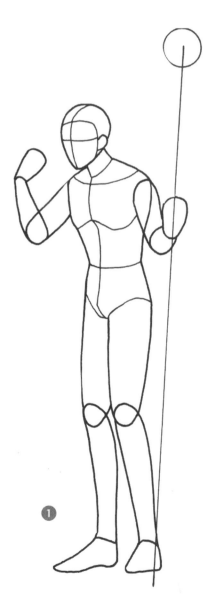

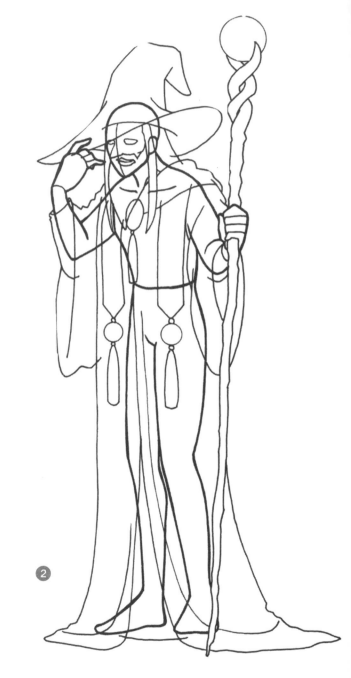

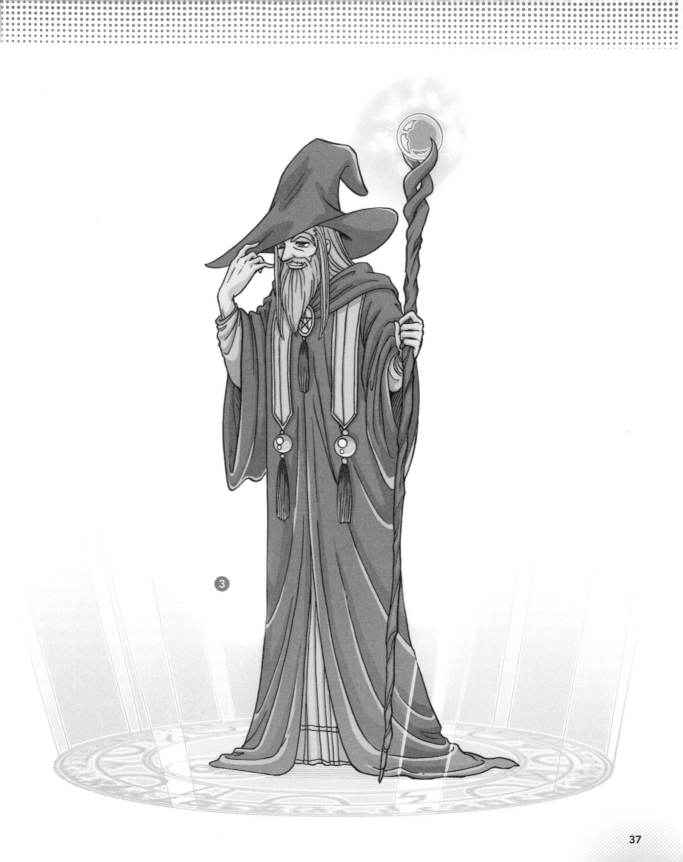

Magical Knight

Unlike the earnest but inexperienced squires of King Arthur fame, teen knights in manga are seasoned fighters.

The knight can be fitted with armor from head to foot, but where's the fun in that? Your reader would never get to see your character, and the poses would be as dynamic as a guy wearing a soda can. So dress him in flashy garments, with as little padding and protective gear as you can get away with.

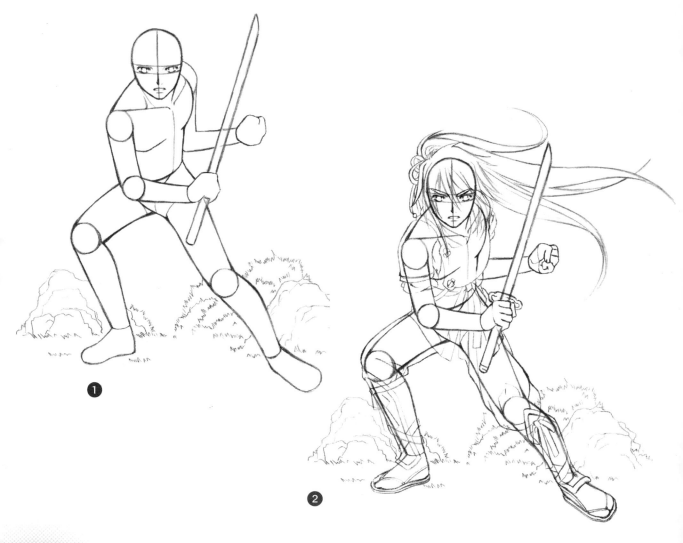

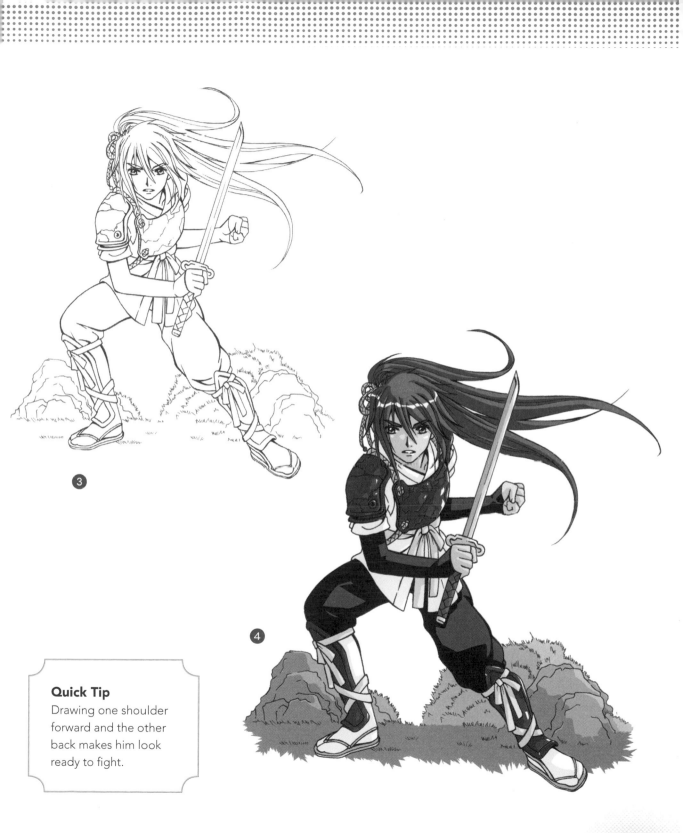

3

4

Quick Tip
Drawing one shoulder forward and the other back makes him look ready to fight.

Air Surfer

Here we use vanishing lines to create the illusion that our character is moving. In fact, she's surfing through the air at lightning speed with the help of a couple of expert flyers! Her uniform is inspired by a kimono but includes several twists and embellishments, such as a magical flute, ruffles, and a giant bow that ties in the back. Note how her hair sweeps back dramatically, as do the tails on the bow.

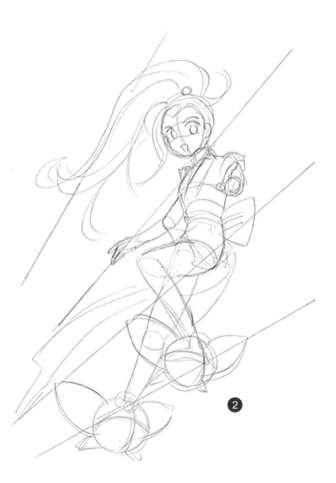

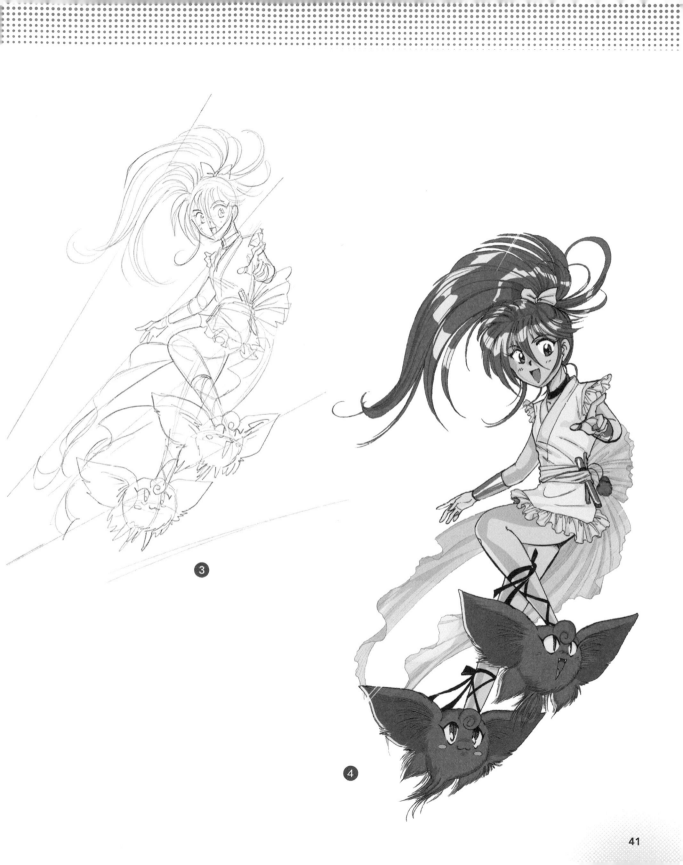

③

④

Magical Woodland Scene

Of course, if you're drawing magical characters, you'll need to be able to draw magical scenes! In a panoramic scene such as this, the width of the landscape allows there to be many different areas of interest, not just one focal point to the scene.

Magical fantasy characters are so popular and versatile in manga that they appear in many different subcategories. For example, this flatly drawn and colorful scene is made in a style called Kawaii, which is known for its cute characters and their adorable, winning personalities. But the style is not generally used in action scenes, such as a fight between a magical girl and a villain.

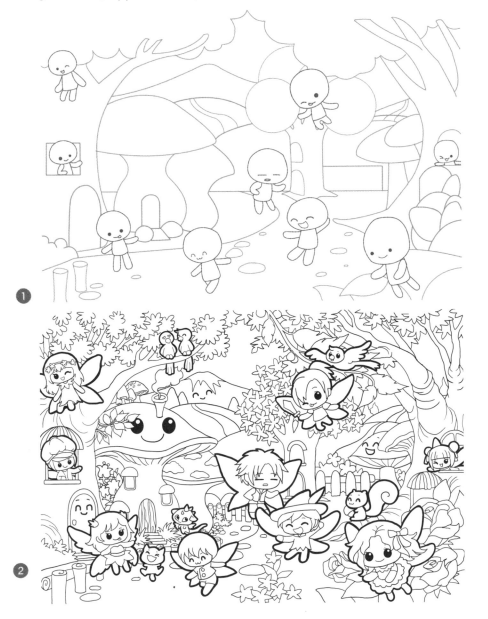

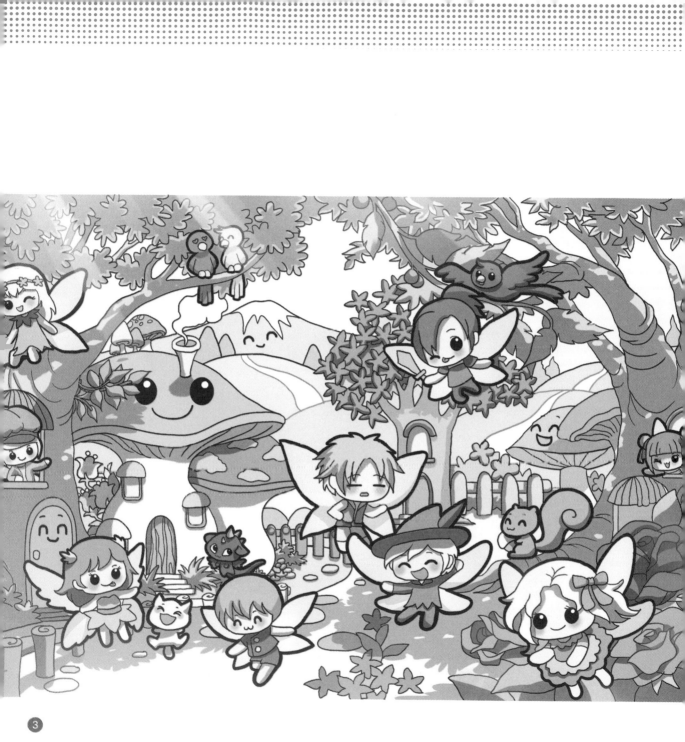

3

Butterfly Fairy

Manga-style fairies come in three types: enchanting, enchanting, and enchanting. Take your time to create a delicate pattern to the interior of the wings, which are generally drawn as butterfly or dragonfly wings (feathered wings are for angels). The hair should flow, swirl, and curl. The typical fairy dress is made from ordinary forest plants, but should nonetheless be designed to appear elegant.

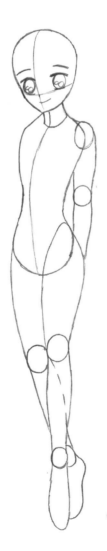

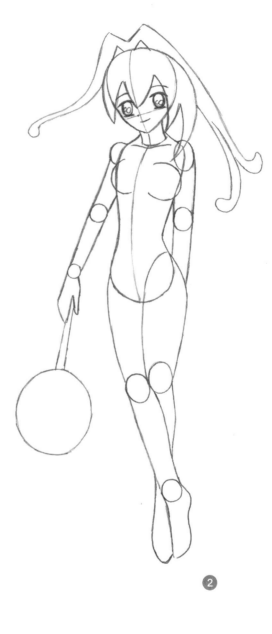

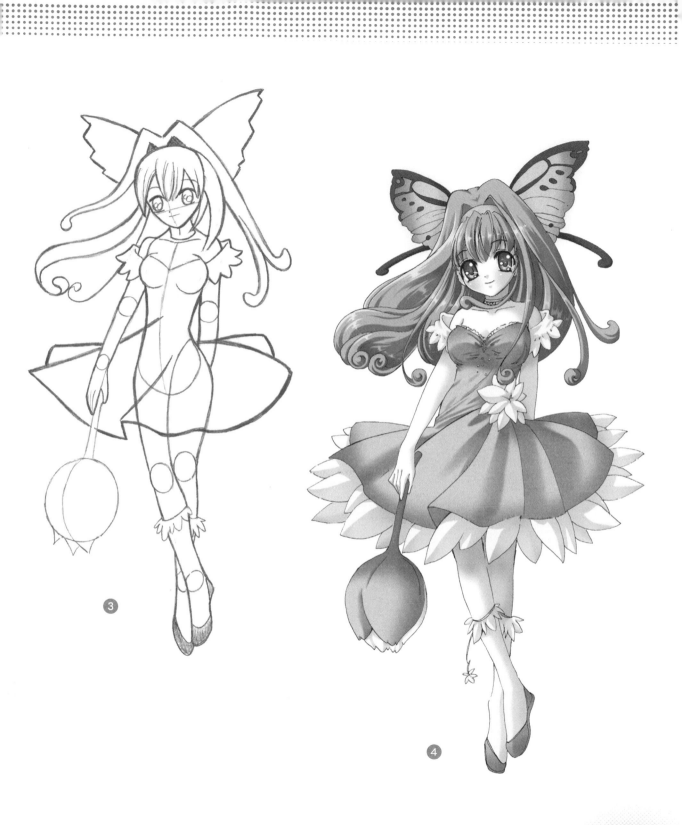

3

4

Cute Fantasy Creatures

Animal characters don't have to be actual, real animals. They can be creatures of your own invention. Take aspects of real animals, and use them as inspiration. Take a look at these next two examples.

Gummy Bat

Take a gumdrop shape, stretch it, add a pair of cute rounded horns, and give it the Cyclops eye treatment (one eye in the center of the head). Now add bat wings, and color the entire thing slime green. What have you got? Beats the heck out of me! But as long as it's cute, it's a winner. The overall simple shapes, funny and harmless monster motifs, and friendly expression make this little guy irresistible.

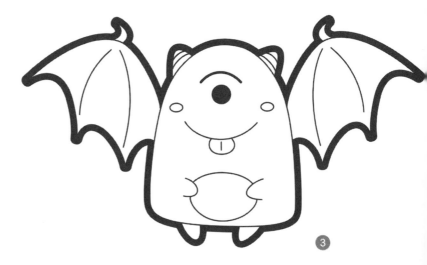

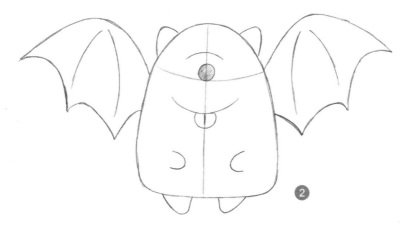

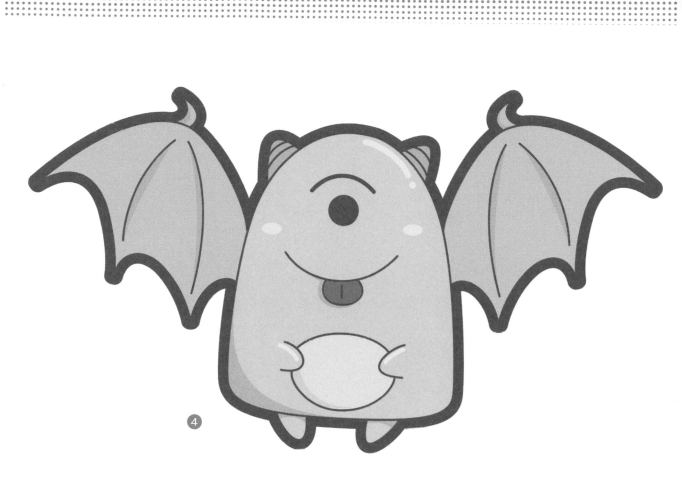

CREATE YOUR OWN MONSTER

You can copy this cute monster just as it appears here, or you can draw it with your own personal twist on the material. Here is a list of elements you can add to create a unique monster:

- Give it two eyes instead of one.
- Make the wings feathered.
- Turn the horns into long, pointed ears.
- Make the mouth a tiny smile instead of a wide grin.
- Give it four tiny legs instead of two.
- Place extra spots in the color design.
- Remove the horns, and add shaggy hair instead.
- Give it a funny nose or an elephant's trunk.
- Change the body shape.

Fantasy Hummingbird

Some fantasy characters are based on real animals but have been changed to appear magical. You can try this yourself. This is a variation on a hummingbird, which is usually small, sleek, and agile. However, this character is roly-poly, wears goggles, and doesn't appear to be moving very fast at all! Taking a character in the opposite way a reader might expect (turning a lithe hummingbird into a chronic midnight snacker) is a great way to create humor.

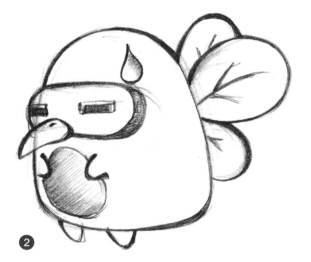

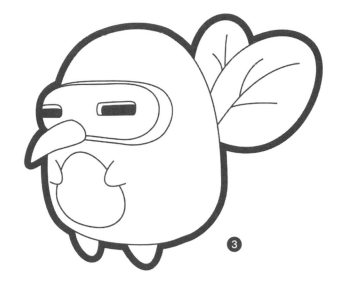

3

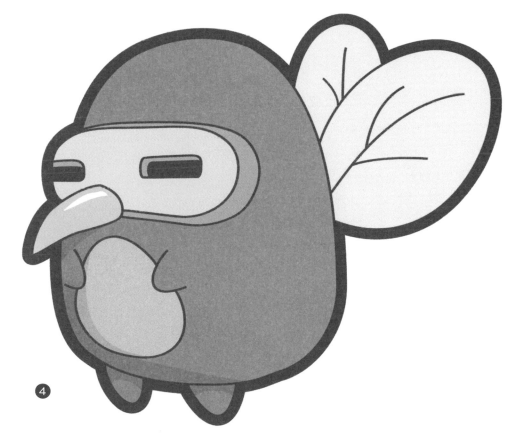

4

Butterfly Droplet

This huggable fantasy friend combines elements, such as butterfly wings, with colorful embellishments inside their wings. When creating roly-poly creatures like this one, the body can be a simple form, such as a raindrop, a pillow, or an egg. Notice that the arms and legs are minisized. With small limbs like this, this creature wouldn't be much good at performing heroic or dramatic deeds. But that's not what it's intended for. It's purpose is to spread happy emotions wherever it appears. I wouldn't recommend drawing long arms and legs; that would make it look like an invading alien from outer space.

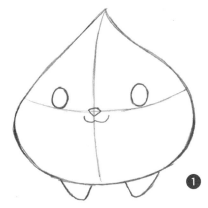

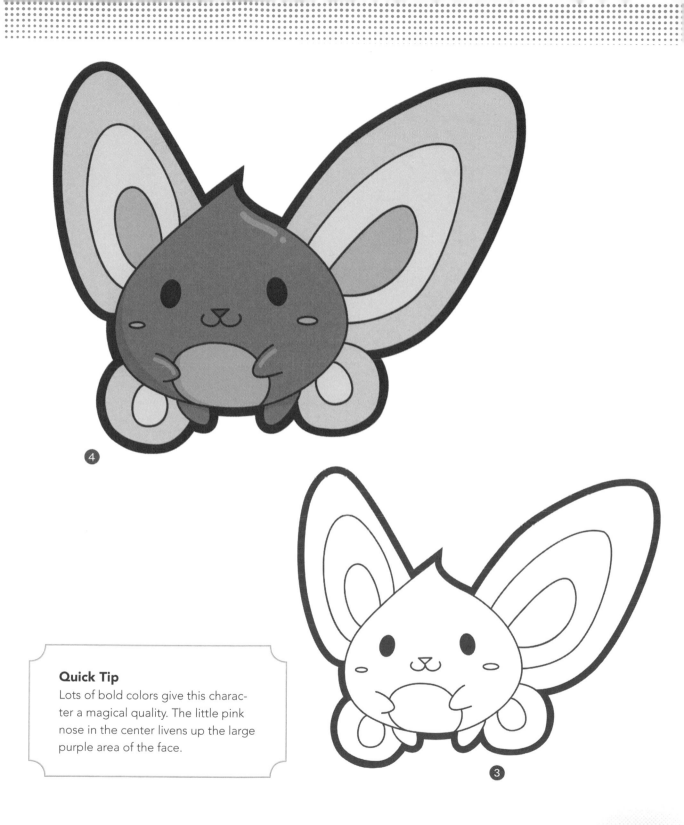

Quick Tip

Lots of bold colors give this character a magical quality. The little pink nose in the center livens up the large purple area of the face.

PART THREE
Let's Practice It

Congratulations! You've made it to the part of the book where you'll get to finish the drawings that are already started. You'll add the missing parts of the drawings here. It's a great way to practice your newly acquired skills and to exercise your own creative license while drawing manga characters.

Give these magical girls wands and special effects to finish off their looks.

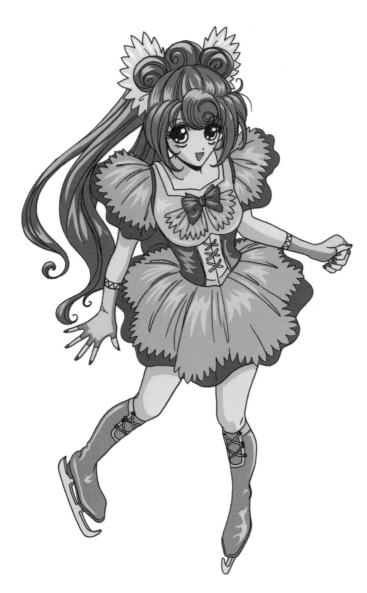

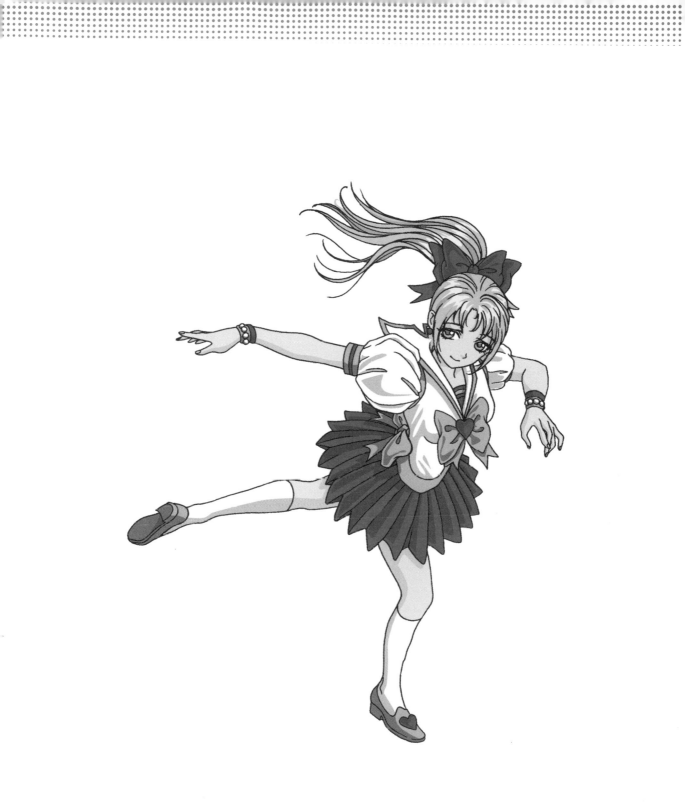

Draw the sorcerer that might carry this staff.

**These characters need magical mascot companions.
Can you draw them in?**

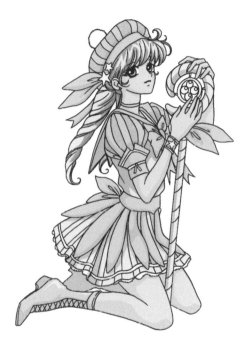

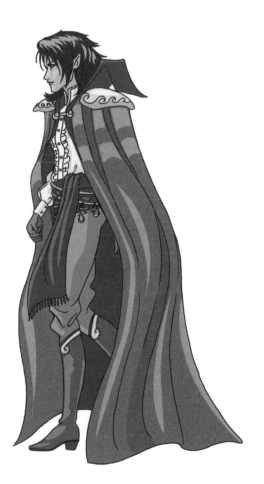

What human companions would these mascots have? Draw them in here.

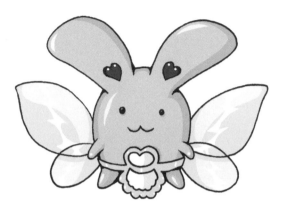

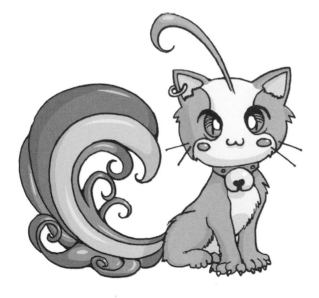

What would this girl look like after transforming into a magical girl? Draw her, complete with magical accessories, and a mascot, here.

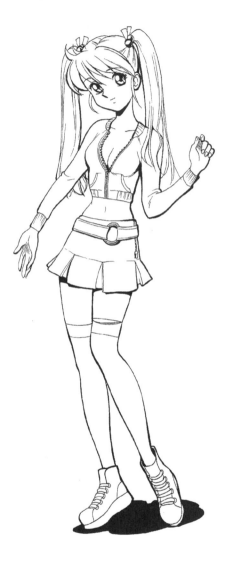